THIS IS MY
Faith Journey

Copyright © 2022 by Jennifer Frost, Faith and Fabric.

All rights reserved. No part of this book may be reproduced by any means without the written permission of the author/publisher.

Printed in the United States of America.

Cover, interior design, composition, graphic elements, and quilt blocks by Jen Frost, Faith and Fabric.

Scripture texts in this work are taken from the NIV Bible Edition.
All Rights Reserved.

The Kindle Edition of this book includes hyperlinks to daily scripture readings.

Visit Faith and Fabric ™ at https://faithandfabricdesign.com for additional information or to purchase a copy of the Holy Week quilt shown on the pages of this book. Quilt blocks shown are part of the *Scripture Quilts* ™ Block Collection.

AUTHOR'S Comments

I am so excited to join you on a Lenten journey through scripture as we explore our redemption story! Each of these quilt blocks, and accompanying devotion, were selected and written as they play a key role in events during one of the holiest of weeks that we celebrate as Christians. By taking the time to explore each of these eight days, we see a deeper meaning and relevance in our own redemption story.

There are eight devotions in this book, which is designed to begin each year on Palm Sunday and end on Easter Sunday. The devotional length for each day varies, as does the length of each reading. Thoughtful questions accompany each day's reading, providing opportunities for you to dive deeper into that day's scripture. Should you need more space for your personal reflection, additional pages have been added at the end of this book.

A note about the blocks: the quilt blocks in this book are part of our signature *Scripture Quilts*™ Blocks series. Together, the blocks form the basis for the Holy Week quilt pattern, though the blocks are also available as stand-alone patterns.

Lastly, if you enjoy this devotional, I invite you to view our other devotionals for quilters, available on Amazon: bit.ly/faf-devotionals

I look forward to journeying with you this Lenten season,

Jen Frost
Faith and Fabric
https://faithandfabricdesign.com

P.S.: Enjoy a complimentary Creation quilt block; it can be downloaded here: bit.ly/faf-creation

TABLE OF Contents

Author's Comments .. 3
Day 1: Palm Sunday .. 6
Day 2: Holy Monday .. 8
Day 3: Holy Tuesday ... 10
Day 4: Spy Wednesday ... 12
Day 5: Holy Thursday ... 14
Day 6: Good Friday .. 16
Day 7: Holy Saturday ... 18
Day 8: Easter Sunday ... 20
Notes Pages ... 22

DAY 1: Palm Sunday

"Hosanna to the
Son of David!"

"Blessed is he who comes
in the name of the Lord!"

MATTHEW 21:9

READING: Matthew 21:1-11

DEVOTION: On Sunday, the crowds welcomed Jesus as he rode into the city; palm branches were put down on the ground, creating a path for him to ride upon. People shouted with joy, calling him "Hosanna to the Son of David! Blessed is He who comes in the name of the Lord! Hosanna in the highest heaven!" He was treated like the king he is!

...and then, in the fickle way people can be, Jesus wass sentenced to death just five days later.

If someone asks you if you behave more like the crowd who welcomed Jesus *or* the crowd who condemned him, there's a good chance you—and I—would say the former. Yet, there was so much overlap in those crowds; many who welcomed Jesus on Sunday turned their backs on him by Friday. We, too, can look into our own hearts and see there are times when we've behaved like the crowd. One day we love and honor Jesus through our thoughts and words, and the next day we consciously turning our back by making choices that go against his teaching. Whether it's when we swear at the driver who cut us off on the freeway, share a bit of gossip with a friend, complain about our spouse or children, or sleep in on Sunday instead of attending church services, we, too, can be fickle.

DAY 1: Palm Sunday

GO DEEPER:

As Jesus entered Jerusalem on the donkey, palm branches were placed at his feet to both celebrate and welcome him. Each day, we have the opportunity to welcome Jesus into our hearts and into our homes. What is one way you can invite and welcome Jesus into your daily routine today?

Many in the crowd who originally welcomed Jesus quickly turned on him just a few days later. Our hearts are emotionally driven, and sometimes our hearts take us to places other than the places that God wants us to be. What is one emotion that you've been struggling with lately that—when it takes over—tempts you away from what you know to be right and true?

Compare your answers to the above two questions. When you feel your emotions leading you astray, how can you stop in that moment and invite Jesus into your heart?

DAY 2: Holy Monday

"It is written,"
he said to them,
"'My house will be called
a house of prayer,
but you are making it
a den of robbers.'"

MATTHEW 21:13

READING: Matthew 21:12-13 and Mark 11:15-18

DEVOTION:

On Monday, after arriving in Jerusalem the previous day, Jesus again visited the temple and was aghast to find the illicit vendors and money changers. He overturned the tables and benches, telling them that they were making "my house a den of thieves".

Our former pastor had a strict policy on tables on the plaza after Mass would end; he was very careful to ensure that we didn't create a situation similar to the one from so many years ago! Yet, it wasn't necessarily the gathering of the people, the selling of the goods, or the money changers presence that angered Jesus – it was HOW they were doing it. As Jews came into the city to offer sacrifice at the temple, doves were being sold at a premium price and money changers were charging higher than normal rates. Truly, instead of vendors, they were behaving like thieves and using the people's worship of God for disproportionate profit for themselves.

DAY 2: Holy Monday

GO DEEPER:

This story is a gentle nudge for us in taking a deeper look at the times, in our own lives, where we may knowingly earn disproportionate profit for ourselves. Maybe the grocery store clerk mistakenly priced the organic apples you bought at check-out as regular apples. Maybe the restaurant inadvertently left that second glass of wine you ordered off the final bill. Maybe you held onto a beautiful platter that was forgotten at your house after a potluck. If we knowingly allow these things to happen, we are disproportionately profiting for ourselves, and we, too, need our tables — and hearts — overturned. What tables do you have that may need to be overturned?

We have been given the opportunity to make things right with our Creator through the gift of reconciliation. Whether you call this gift confession, penance, reconciliation, or by another name, the gift is the same: an opportunity for atonement.

There are four general steps that can lead us to true reconciliation. First is contrition: our sincere sorrow for having offended both God and others as a result of our thoughts and actions. After all, our sins can't be forgiven if we don't have genuine sorrow over having committed them *as well as* a firm resolve not to repeat them again. We then confess our sin, either out loud, during prayer, or with a priest or pastor. Vocalizing our actions creates an opportunity for us to truly put into words what we knowingly did wrong. We then can help make things right through acts of penance and reparation with those we have offended. Lastly, we ask God for absolution, which is a way for us to fully reconcile the relationship we have with Him as we move forward in our committed to do better.

Use these four steps as they speak to you.

DAY 3: Holy Tuesday

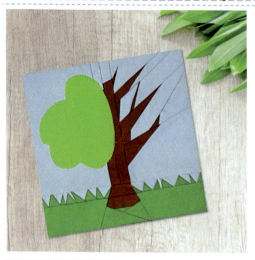

> In the morning,
> as they went along,
> they saw the fig tree
> withered from the roots.
>
> MARK 11:20

READING: Mark 11:12-20

DEVOTION:

On Monday, as Jesus was leaving Bethany and heading into Jerusalem (where he would overturn the tables of the money changers in the temple), he was hungry. He saw a fig tree, green and lush. Scripture tells us how the tree bore no fruit, for it was not the season for figs…yet Jesus curses the tree. The next day, Tuesday, as Jesus and the disciples were again passing the tree, they saw that it had withered overnight.

Jesus would have known that the tree wasn't in season to bear fruit, so we must ask ourselves: why did he condemn the tree? As Jesus has done so many times, he uses this as a teaching opportunity. The tree was a symbol, in that moment, of Israel. On the outside, the tree appeared to be lush and fruitful, but on the inside its branches were baren of fruit. In Israel, there were those who preached their faith and – like the fig tree – appeared from the outside to be devout and full of trust in the Lord. On the inside, though, they were empty. Their faith wasn't in God, but in worldliness. They bore no fruit.

DAY 3: Holy Tuesday

GO DEEPER:

There are times in our own lives when we are like that fig tree. We may go to church each week, or be regulars at bible study, yet still bear no fruit. Maybe we *say* we've forgiven someone for a wrong, yet our actions don't match someone who has truly forgiven. Maybe we *talk* about the importance of our faith, but never find time to make it to church on Sunday. Be honest. What is one branch on your tree that may not be bearing as much fruit as it should?

LET'S EAT:

Meals are a wonderful opportunity for us to gather and nourish both our bodies and souls. As you prepare your dinner on Holy Tuesday, bring this delicious recipe to the table. It serves not only as a tasty appetizer, but as a conversation starter as you and those you dine with share the meaning behind Holy Tuesday.

INGREDIENTS:

- 2 ounces of fresh goat cheese
- 1 tablespoon of reduced balsamic vinaigrette
- 12 fresh figs
- (optional) sea salt

RECIPE:

- Using your fingers, roll the goat cheese into 24 balls, each approximately 1/2 tsp. Cut the figs in half. Press a ball of cheese into the center of each fig, and place on large serving plate. Drizzle with the vinaigrette and dust lightly with sea salt (optional). Serve immediately and enjoy!

DAY 4: Spy Wednesday

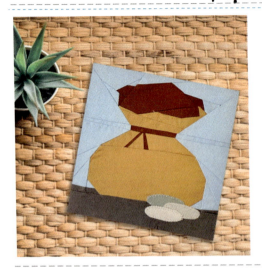

Then Satan entered Judas Iscariot, who was one of the Twelve.

LUKE 22:3

READING: Luke 22:1-6

DEVOTION:

Judas Iscarot was the treasurer for the disciples. He managed their funds, which implies he had a an interest in managing money…and, as John 12:4-6 tells us, it wasn't always an honest interest he had. As a keeper of the change purse, he often helped himself to the funds he was entrusted to care for.

Satan used Judas's love of money and his predisposition to sin to take hold of him. We, too, have predispositions to certain types of sin, sins our pastor calls our "favorite sins". Those we seem to repeat time and time again. Those that we know are wrong, but sometimes justify away. Those we find ourselves succumbing to and confessing on a regular basis.

It's these sins that we already let happen that can be twisted and turn into our biggest weaknesses. In Judas's case, it was his petty theft of and love for money. Satan used that against him. We can take a look in ourselves, and see what "little sins" (or big ones) we commit that may become opportunities for evil to take root.

DAY 4: Spy Wednesday

GO DEEPER:

Take a moment to think of your "favorite sins" - those sins you seem to repeat over and over again. This may even be the same answer you gave yesterday, when asked to respond about which branches on your tree need pruning. Either rewrite your answer from yesterday down here, or write down your "favorite sins" that you find yourself struggling with.

Think back to the reading from today. "Satan entered Judas...". Satan used one of Judas's "favorite sins" — his love of money—as a way into his heart. He took something that, at its root, isn't inherently evil, and contorted it into something that is. Judas became so obsessed with money that he traded Jesus's life in for the price of thirty silver coins.

How does looking at your "favorite sins" change when you look at it not just as something that keeps you from being the person you were created to be, but one that serves as a foothold for the Evil One to take hold?

DAY 5: Holy Thursday

For I received from the Lord what I also passed on to you.

1 CORINTHIANS 11:23-25

READING: Matthew 26:17–29, Mark 14:12–25, and Luke 22:7–38

DEVOTION:

While the readings above all contain the longer, more robust version of the Last Supper, we're instead going to focus on a single line from 1 Corinthians. This one line is like a robust reduction sauce, if you will, where everything has been gently boiled away until only the essence remains.

"For I received from the Lord what I also passed on to you." There is so much beauty in this one verse. When Paul wrote this sentence in the letters to the Corinthians, he was serving as a conduit. He was transmitting that which he received from Jesus onto someone else – in this case, those of Corinth.

Paul's (then Saul's) story is a story of conversion. After being a leader of the Christian persecutions happing throughout the region, Saul experienced a radical change after the risen Christ verbally addressed him while on the road from Jerusalem to Damascus. Left blind, his sight was restored in more ways than one. Physically, he was able to see again three days later after his sight was restored. Spiritually, he was baptized and went on, as Paul, to write a majority of the 27 books in the New Testament. Paul took what he received and passed it on to those around him for generations to come.

DAY 5: Holy Thursday

GO DEEPER:

Each week at our church service, many of us have the opportunity to receive the breaking of the bread and drinking of the wine. If you're like me, your heart may even light up as you feel the power of Christ's sacrifice at the time you receive! We are made whole, we feel Jesus's love, and we walk away feeling fed.

Like Paul, we now become conduits. It's our job to take that spiritual nourishment we received and pass it on. Think concretely for a moment. Who can you pass on Jesus's sacrificial love to? How will you share it this week?

At the Last Supper, Jesus not only offers himself as the sacrificial lamb of Passover but teaches that the disciples are to also follow the same sacrifice in the same way. For many of us on Sundays, we have the opportunity to break bread and wine and share in communion with our sisters and brothers in Christ. We carry on a tradition that started over two thousand years ago. In what ways do you find your heart and soul nourished by taking part in this ancient spiritual act?

DAY 6: Good Friday

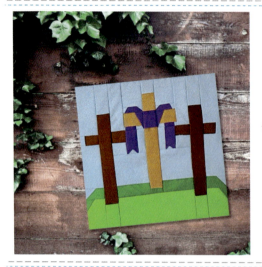

> For God so loved the world that he gave his only Son, that whoever believes in Him should not perish but have eternal life.
>
> JOHN 3:16

READING: John 3:16

DEVOTION:

Of all the verses in scripture, this is probably *the* most popular and most recognized. Sometimes, when things become so well known, they lose their value and become nothing more than a catch phrase.

Let's break it down and really look at this line of scripture: "For God so loved the world..." – throughout scripture, we read about God's love. It's endless. It's infinite. It's always there, no matter what we do. Even Adam and Eve, who committed such a sin that it forever changed our trajectory, were met by God in kindness and in love. In the course of a day, our trajectory brings us into contact with people that we may not see eye-to-eye with, or people we may even want to avoid. Who comes to mind? What concrete things can you do to meet this person, with the same kindness and love that God meets you, the next time you encounter them?

DAY 6: Good Friday

"...that He gave His only Son..." – as a parent or guardian, what is most precious to you? Chances are, it's your child. Perhaps, as a mom of an only, I feel that even deeper – if something were to happen to my child, would I even still be a mom? God gave his one, his only. There wasn't the proverbial "heir and a spare". He gave his only beloved child, and the heartbreak he felt must have been incomprehensible. Can you imagine making the sacrifice God made?

"...that whoever believes in him..." – we all have free will. It's a choice we're given; we can follow Jesus, or we can walk the other way. We can chose to live as a child of God, or we can shrug it off. It's a choice; every day, it's a choice. What is one tangible choice you can make today to strengthen your faith and walk in God's path?

"...should not perish but have eternal life." – the gift of what we receive as a result of Jesus's death is truly such a gift! We have the opportunity to live with him, forever, in heaven alongside all our sisters and brothers who chose this path as well. What a gift indeed! What is one way you can offer thanks for this gift?

DAY 7: Holy Saturday

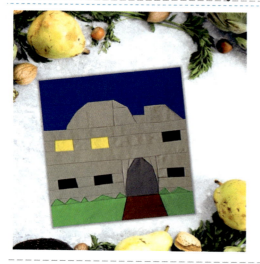

Mary Magdalene and Mary the mother of Joseph saw where he was laid.

MARK 15:47

READING: Matthew 27, Mark 15, Luke 23, and John 19

DEVOTION:

Take a moment to really read the four chapters above. What similarities do you notice?

Each talks about Joseph, who provided the means for Jesus to be buried in a tomb while Mary Magdalene and the other Mary prepare spices and oils with which to anoint Jesus. They run out of time, however, and the Sabbath begins which means they now need to wait until Sunday to anoint Jesus's body.

Little else is said about what happens on the Sabbath. Perhaps those close to Jesus returned to the upper room in town, where just days earlier they had celebrated the Last Supper. We can imagine there was a lot of silence and mourning mixed with longing and hope. Scholars predict they were also likely afraid that the Romans would now come for them because of their loyalty to Jesus.

DAY 7: Holy Saturday

GO DEEPER:

There are times when we are like those closest to Jesus and we, too, feel alone, lost, and scared. They likely spent a lot of time in the upper room, or wherever they gathered, thinking about death. There is a true finality to death that can be scary; often, we choose not to think about it. Death is the end of life on earth, and something we each will experience. Knowing we each have death ahead of us, we can look at our lives from a different perspective – and we can begin to think about the power God has in our lives. Where there was once death, He brought life. What is one area you have been feeling alone in? How does reflecting on the disciples period of waiting bring you comfort?

LET'S EAT:

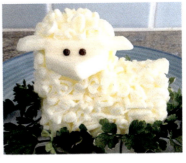

Tomorrow is Easter Sunday, and many of us begin our meal preparations a day early. One beautiful way to create a tasty *and* functional dish for your table is out of butter!

Jesus is our Pascal lamb, and this little lamb, made entirely from two sticks of butter (with a bit of parsley for décor), reminds us of that. Below you'll find a simple tutorial with video to create a lamb of your very own. This is a fun tradition you can begin with your family each Easter! Plus you'll enjoy the added benefit of soft, buttery hands once you've finished creating this beauty. The hardest part? Making the first cut into the lamb come Easter Sunday once brunch time arrives!

Link to Video: https://faithandfabricdesign.com/2013/03/recipe-create-butter-lamb-for-easter.html

DAY 8: Easter Sunday

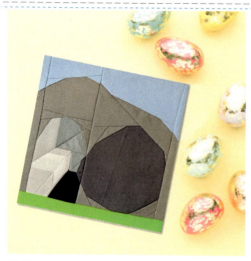

> They found the stone rolled away from the tomb, but when they entered, they did not find the body of the Lord Jesus.
>
> LUKE 24:1-2

READING: Luke 24

DEVOTION:

On the day we now celebrate as Easter Sunday, Mary Magdalene, Joanna, and Mary the mother of James arrived at the tomb. They came prepared with spices as they planned to anoint the body of Jesus On the way (Mark 16:3), they discussed and made further plans on how the were going to move the stone to gain entrance to the tomb.

When the arrived, however, their plans suddenly changed. They found the stone had been rolled away and the tomb was empty. What a surprise and shock this was to them!

The women expected to have to move a heavy stone and to anoint a dearly beloved friend—and instead encountered an empty tomb and an angel! Their role was no less important, and perhaps more so: they were the ones to carry the resurrection message back to the apostles *and* serve as the first witnesses to the prophecy fulfillment.

DAY 8: Easter Sunday

GO DEEPER:

There are times in our life where we approach a scenario expecting a certain outcome and are instead met with a completely different result. What a beautiful lesson these women teach us. The next time we prepare "Plan A" but instead are met with a completely different scenario than we anticipated, may we think back to these women. May we know that we are part of God's grander plan, not our own, and be aware that the role we play may be one greater than we can ever imagine.

Think back to a plan you had in place that didn't go as you planned. Are there ways you can, looking back, see God's hand at work? (If not, remember things happen not in our time, but in His time.)

Jesus appeared first to women. What a beautiful way to share the value women have! Many Christian leaders have written about the "genius of women" and their importance in the life of the continuing Christ's legacy. What role do you play in your church community? What gifts do you have that you can share?

NOTES

NOTES

NOTES

Made in the USA
Columbia, SC
21 July 2022